T0043038

Tales from the
MIDNIGHT
MASQUERADE

Hanna Karlzon

GIBBS SMITH
TO ENRICH AND INSPIRE HUMANKIND

23 22 21 20 5 4 3 2

Tales from the Midnight Masquerade Coloring Book
Illustrations © 2020 Hanna Karlzon.

Swedish edition copyright © 2020 Pagina Förlags AB, Sweden.
All rights reserved.

English edition copyright © 2020 Gibbs Smith Publisher, USA.
All rights reserved. No part of this book may be reproduced
by any means whatsoever without written permission from the
publisher, except brief portions quoted for purpose of review.

Gibbs Smith
P.O. Box 667
Layton, Utah 84041

1.800.835.4993 orders
www.gibbs-smith.com

ISBN: 978-1-4236-5544-2

This book belongs to

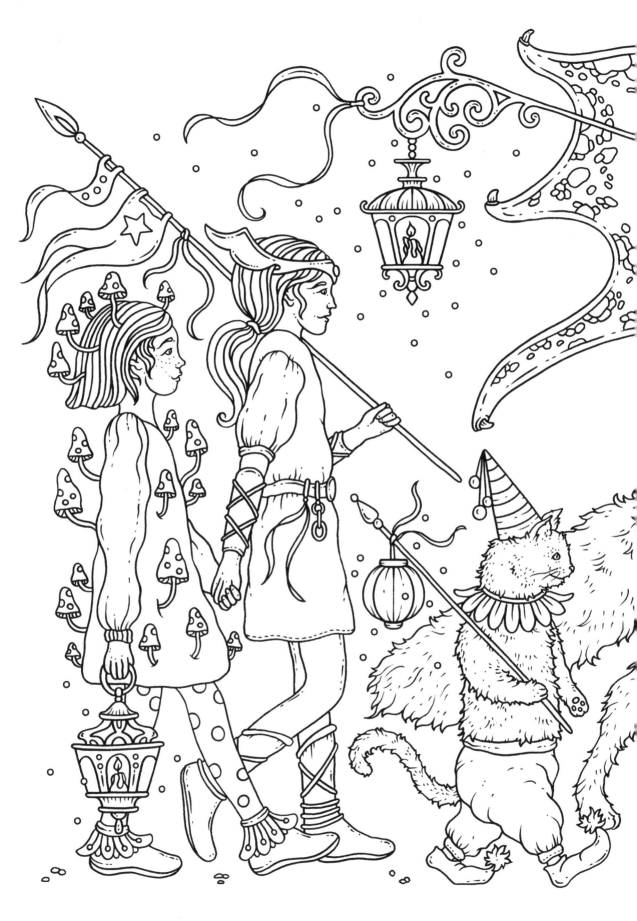

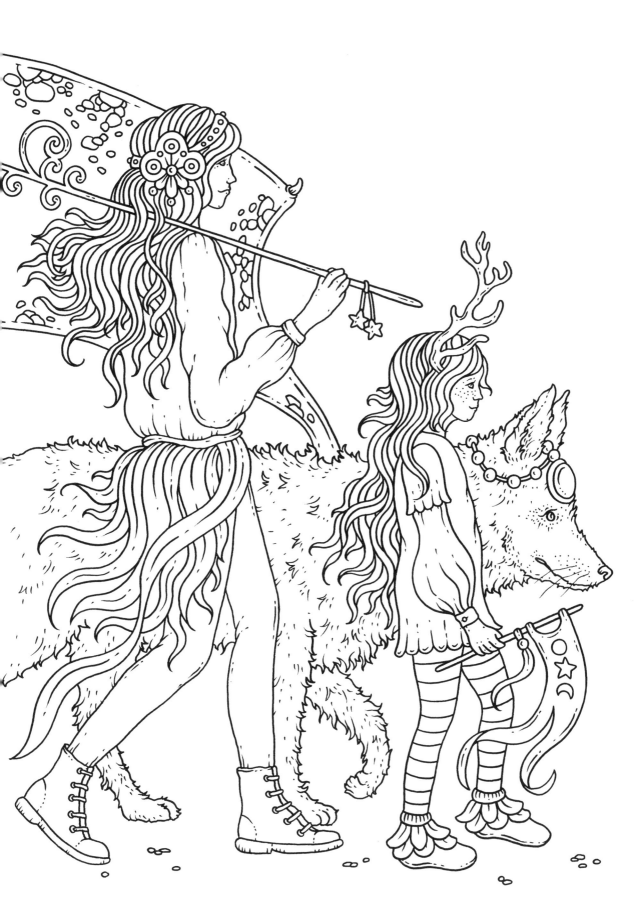

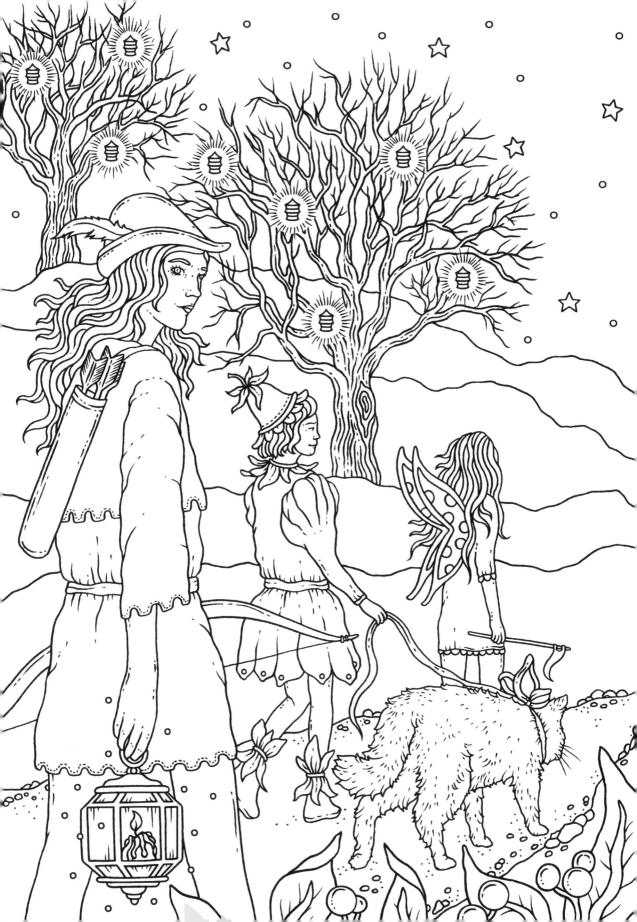

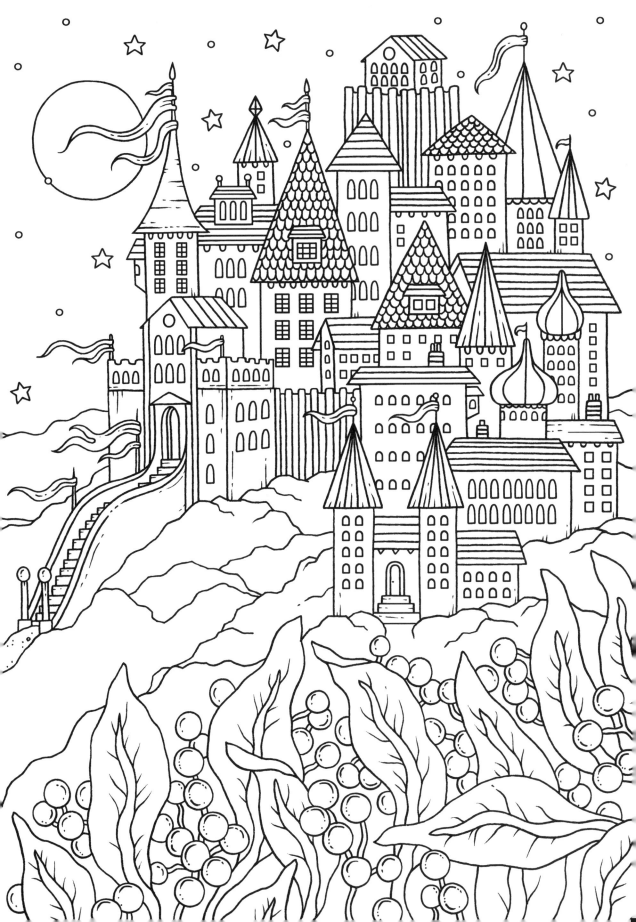

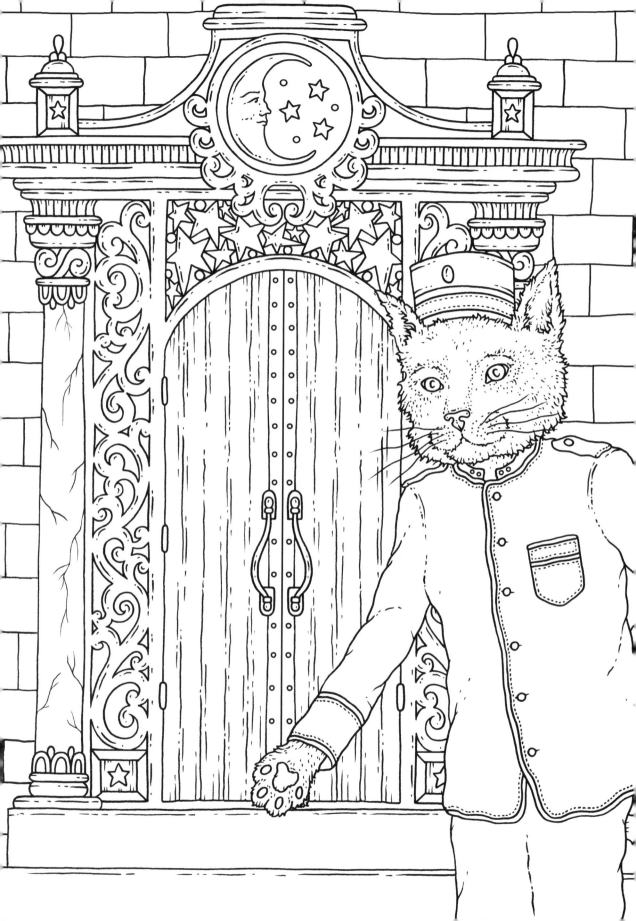

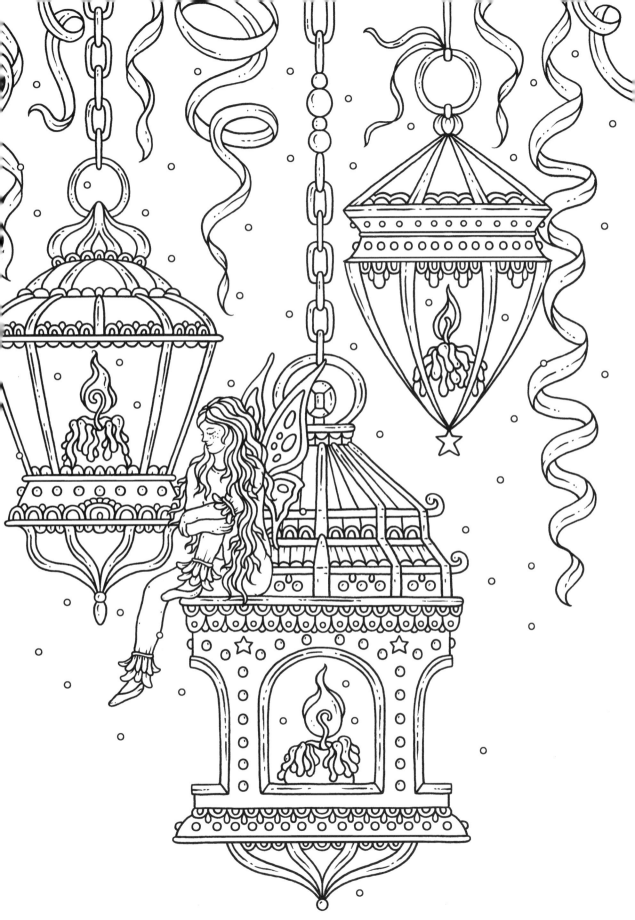

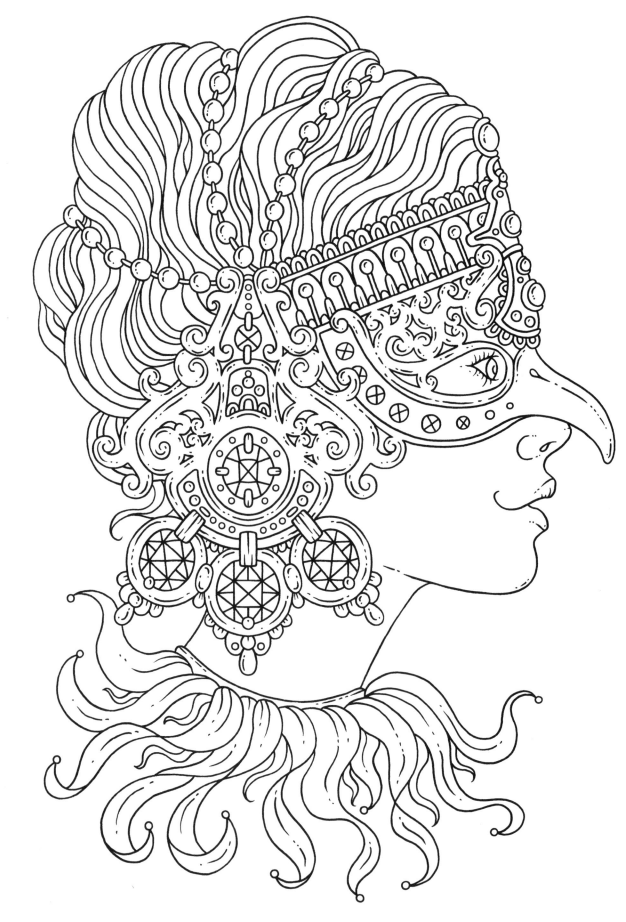

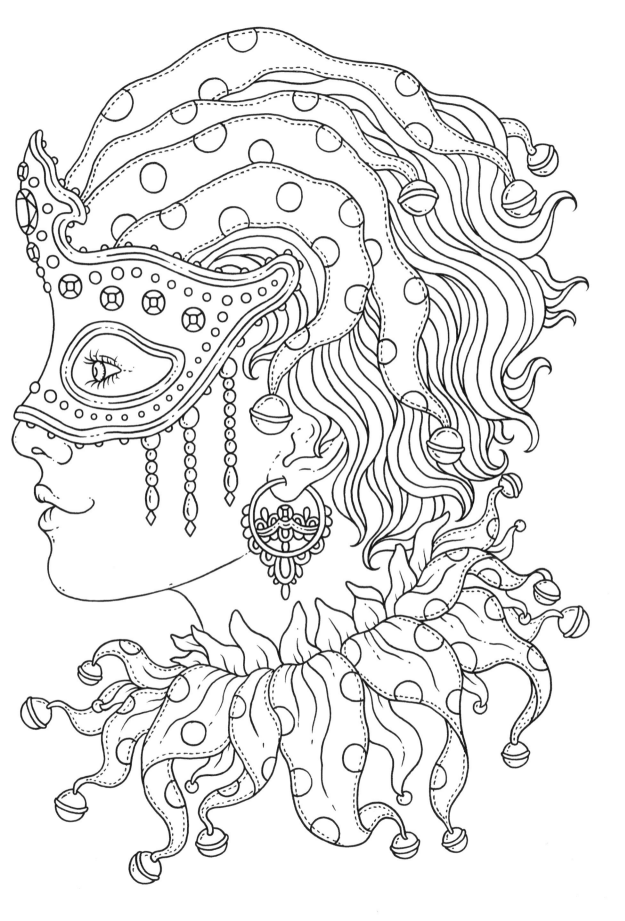

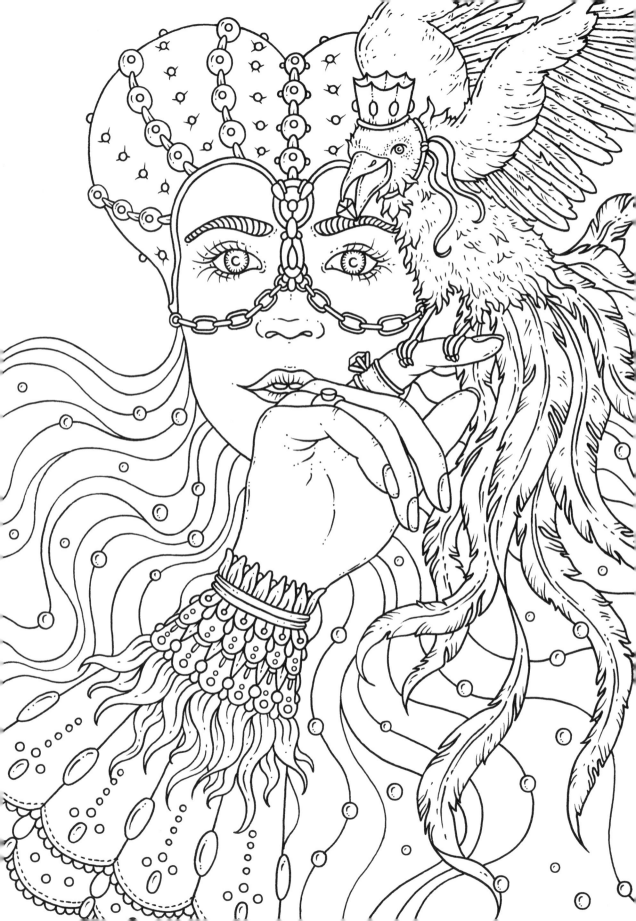

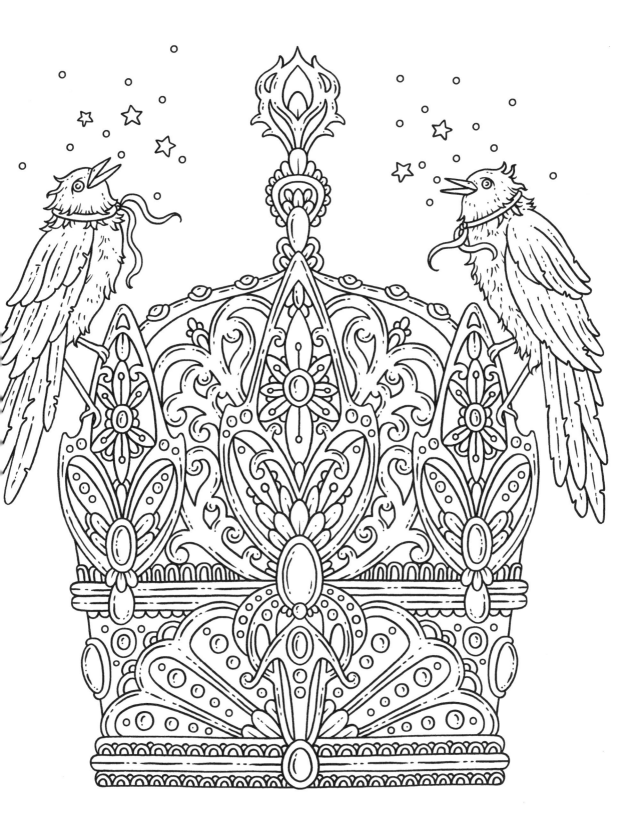

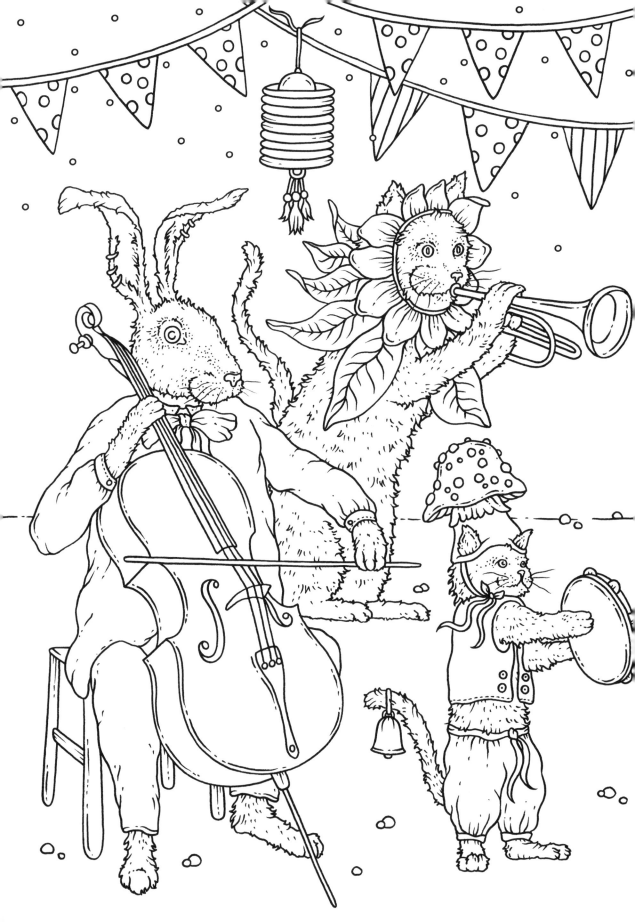

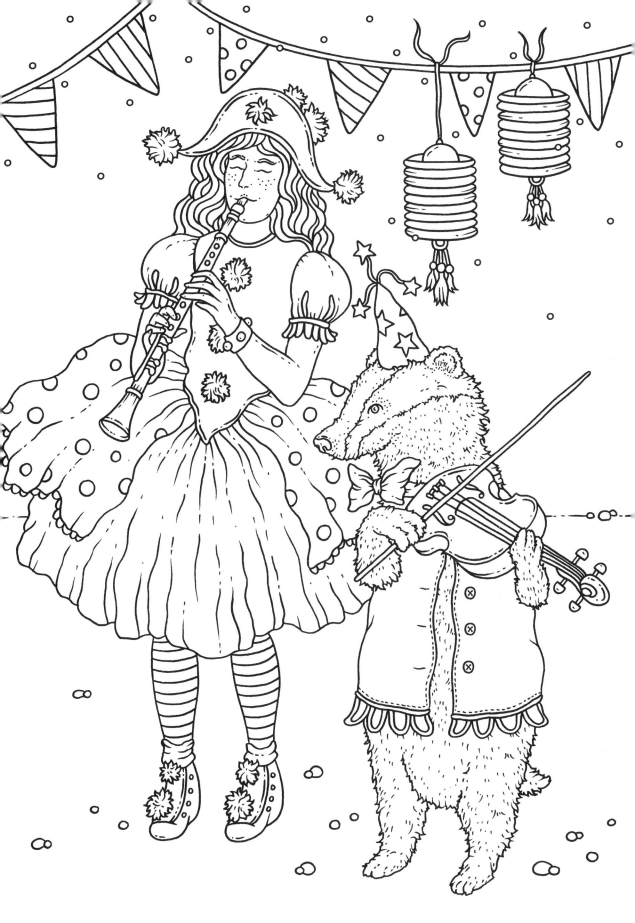

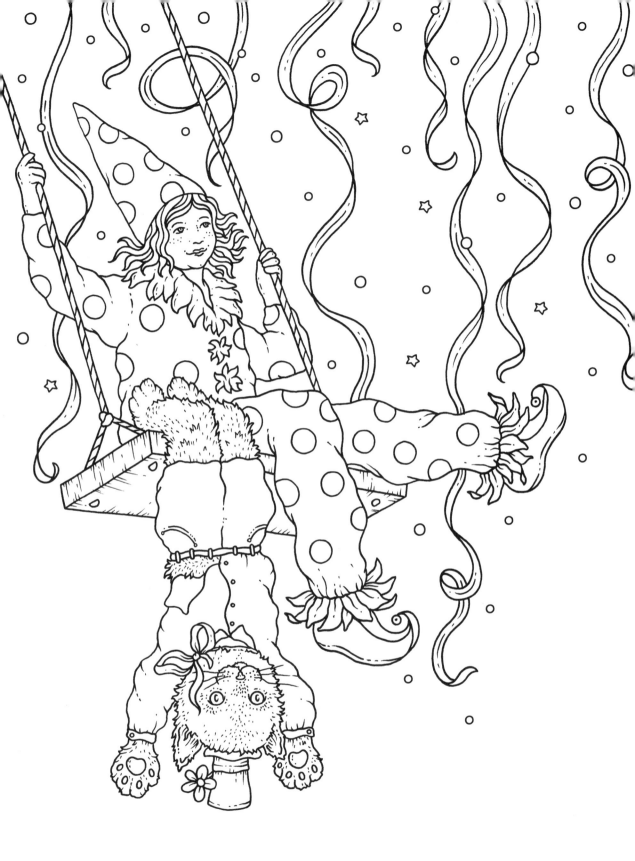

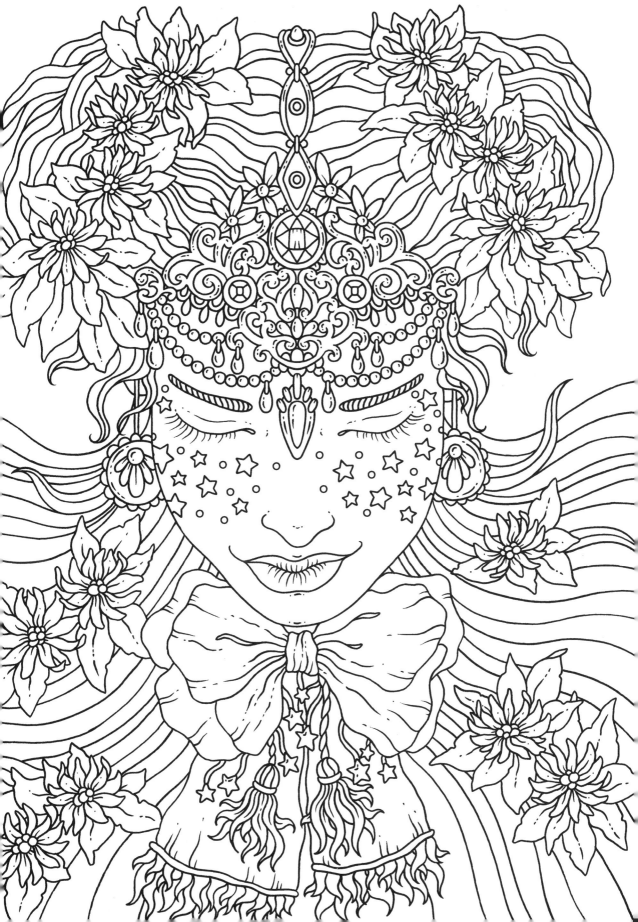

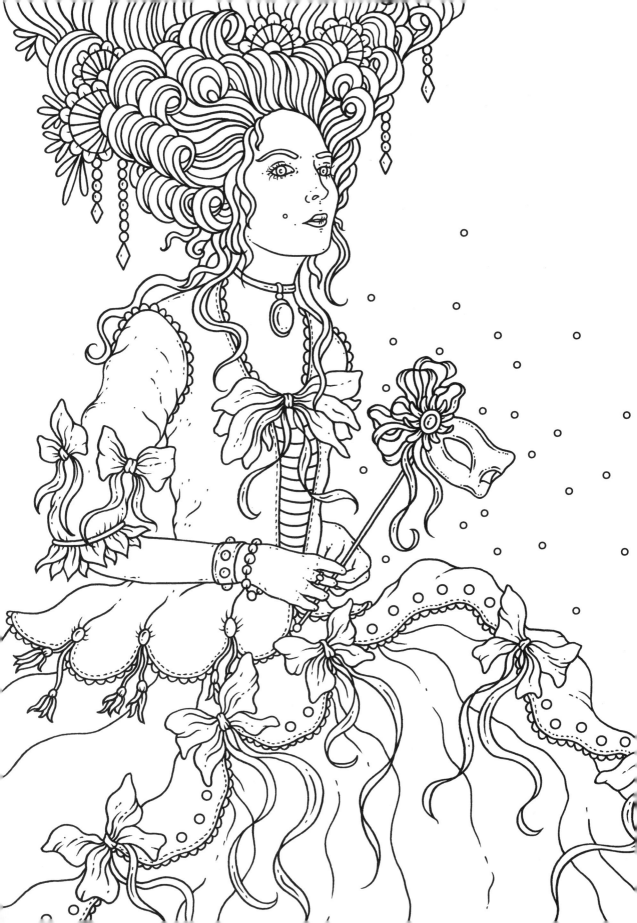

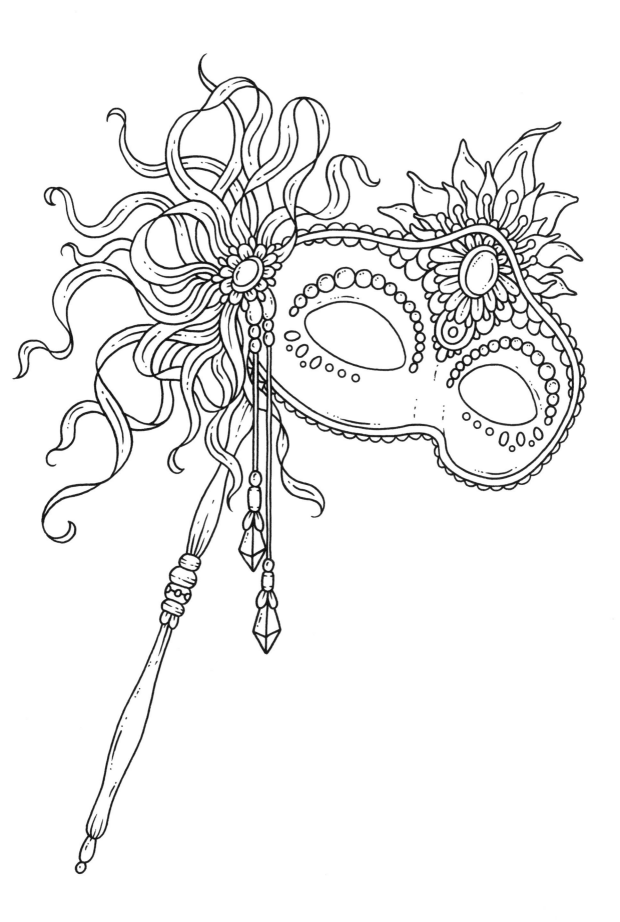

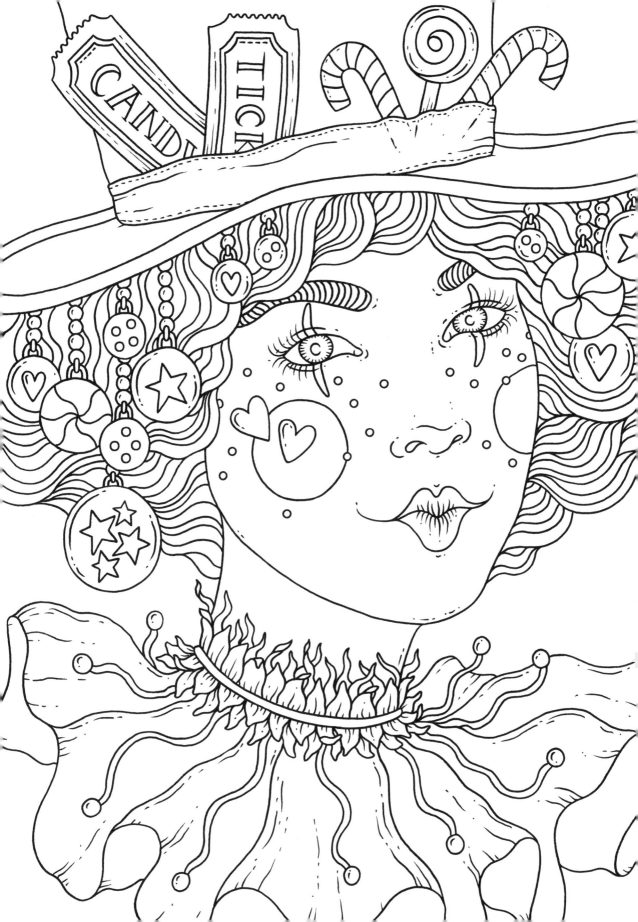

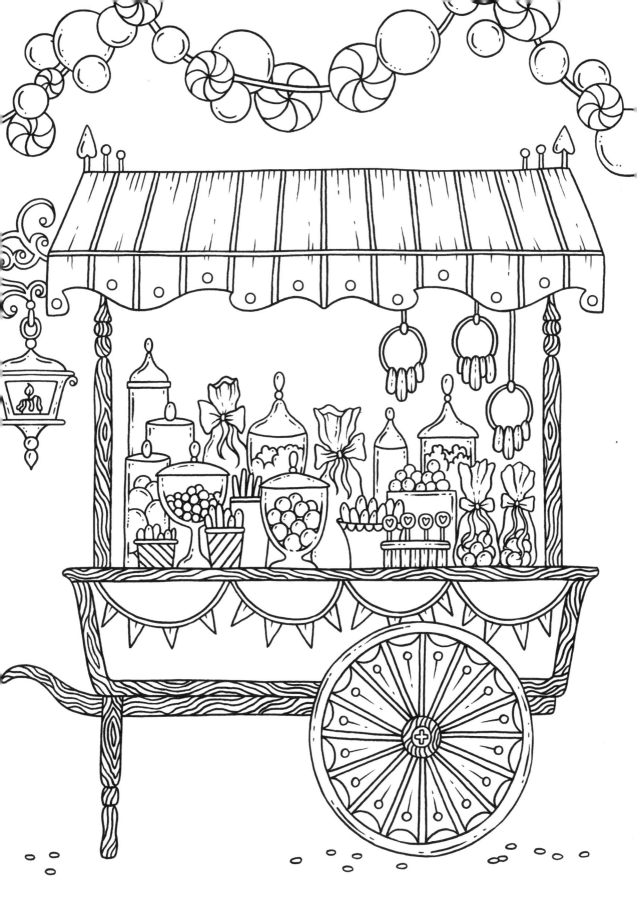

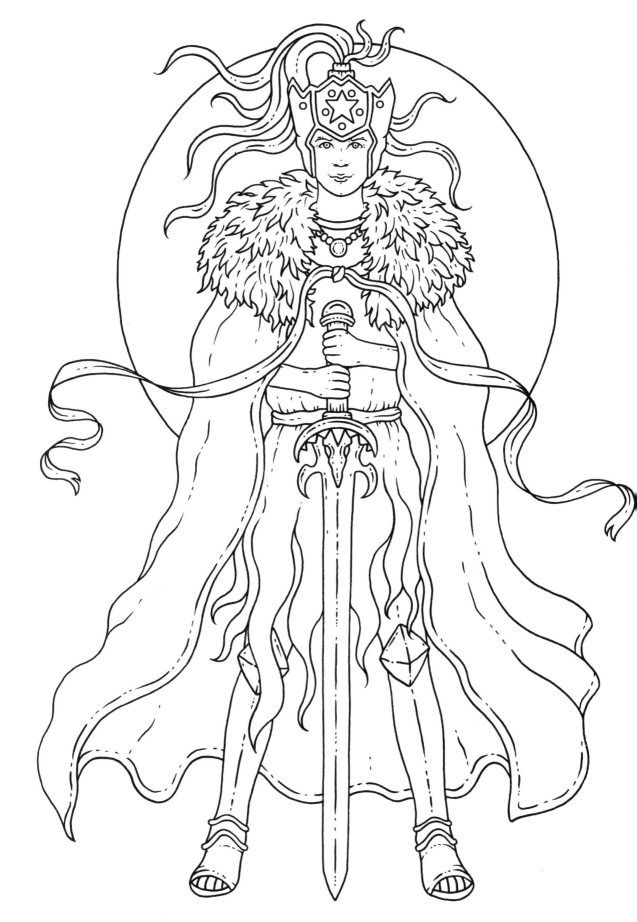

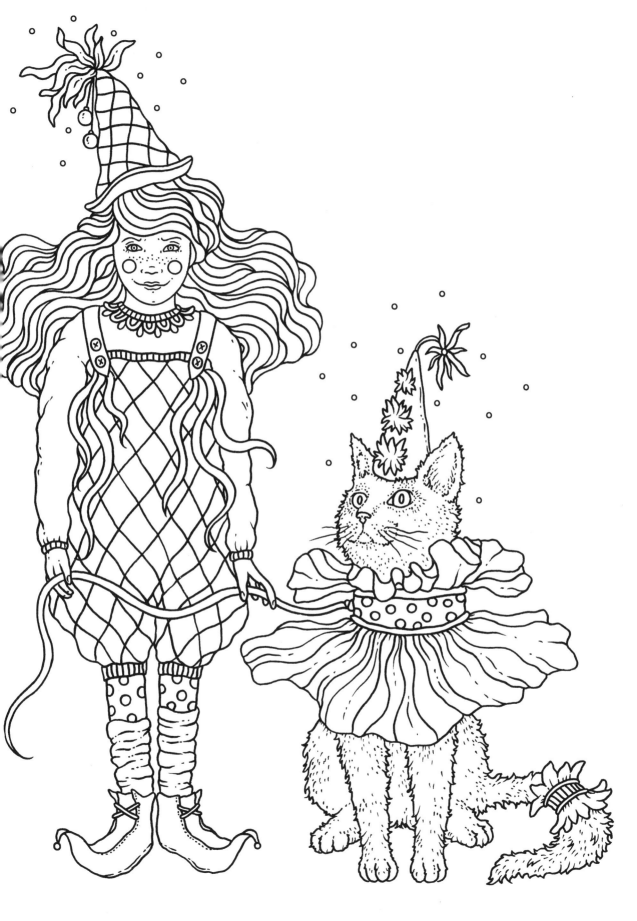

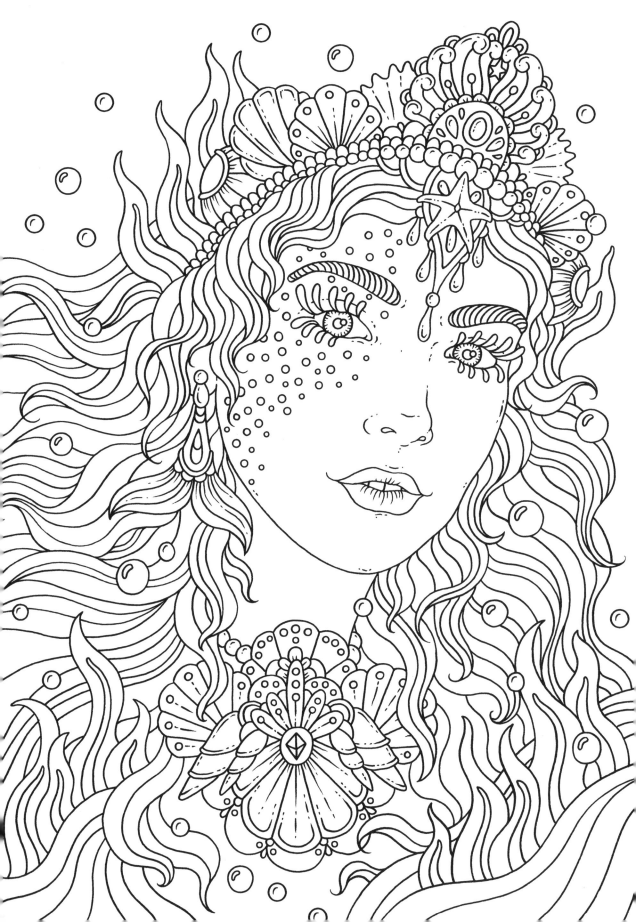

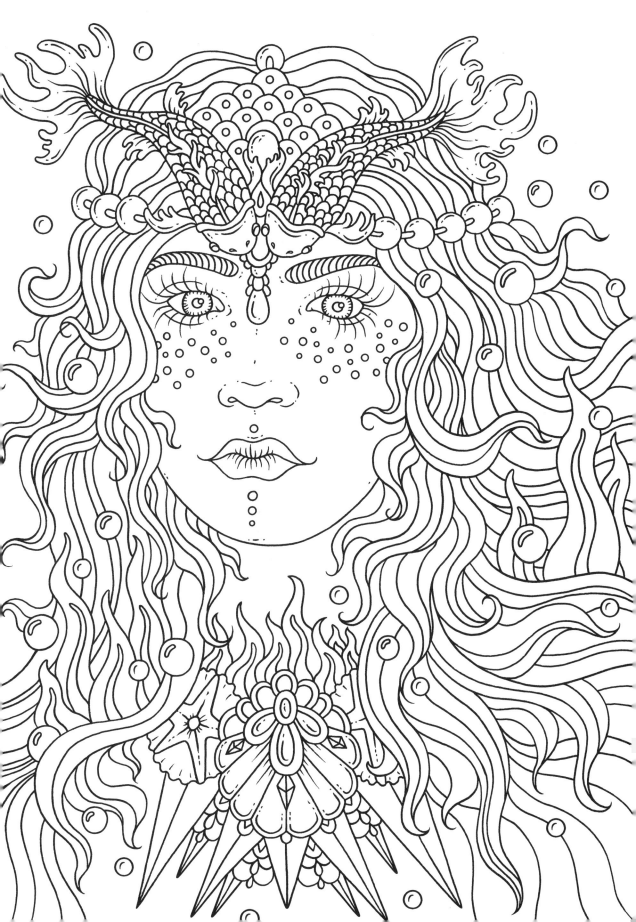

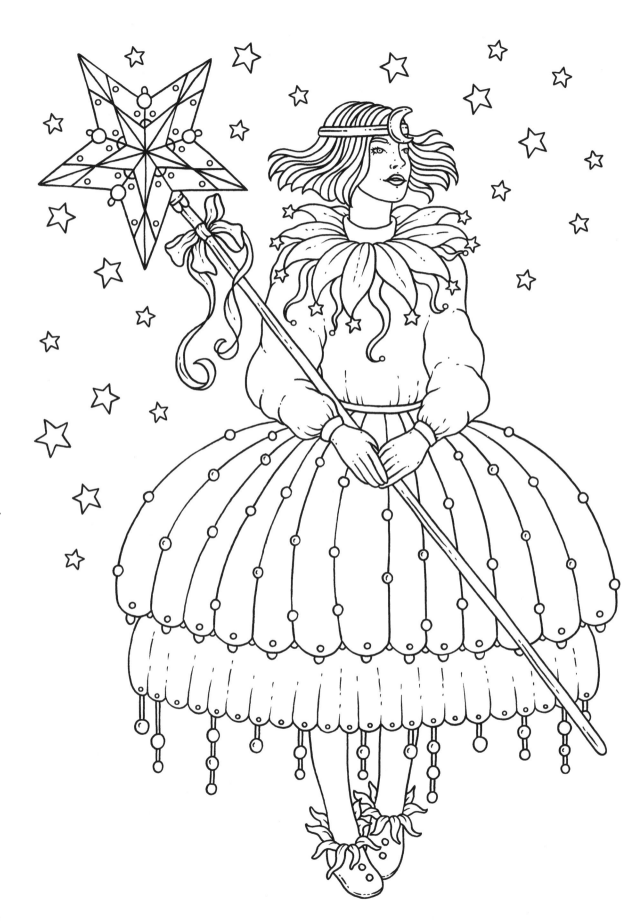

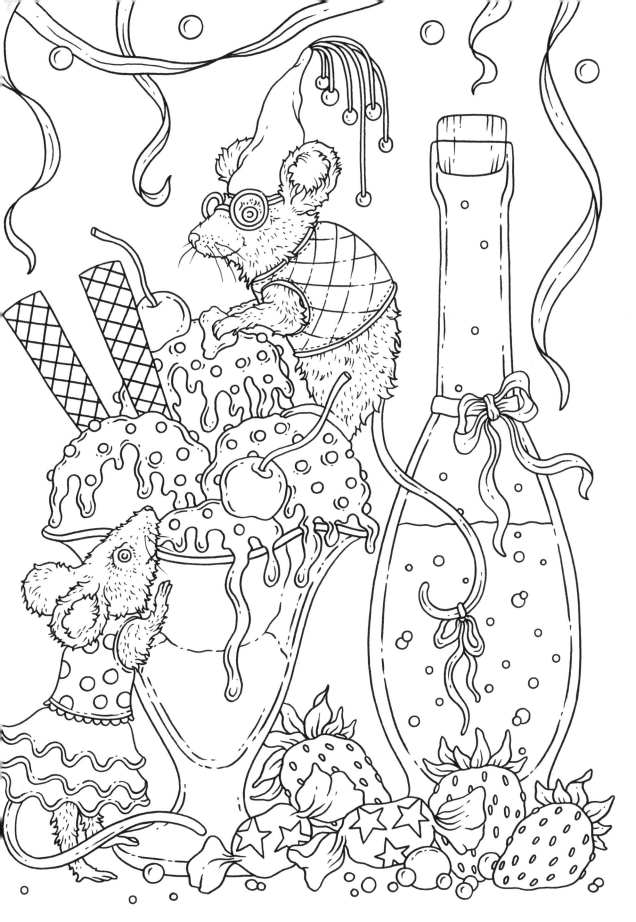

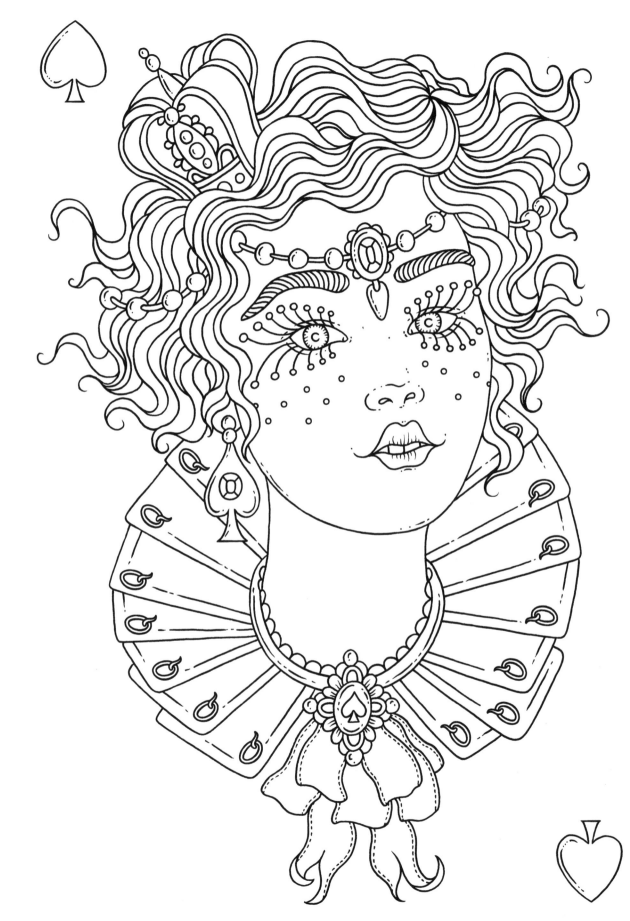

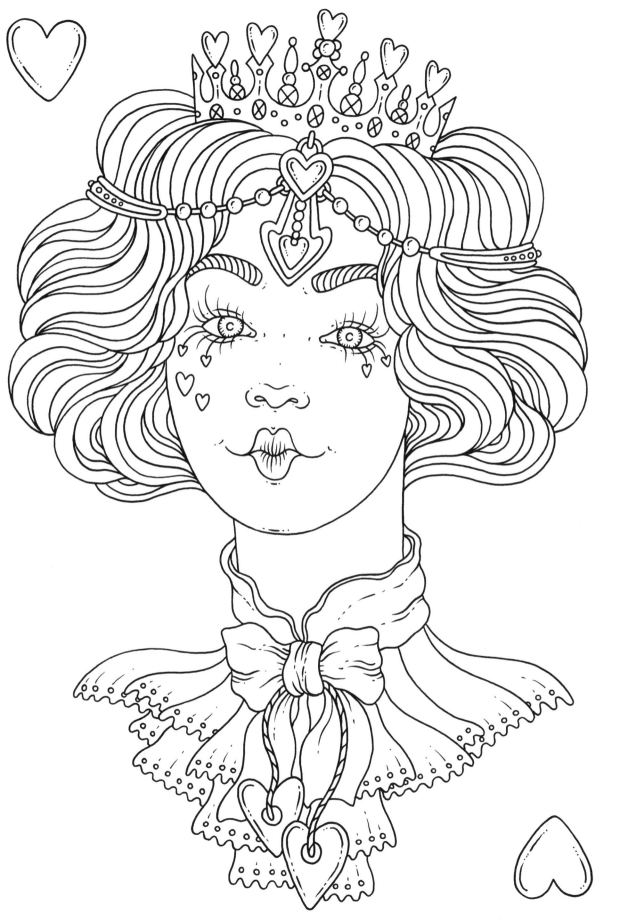

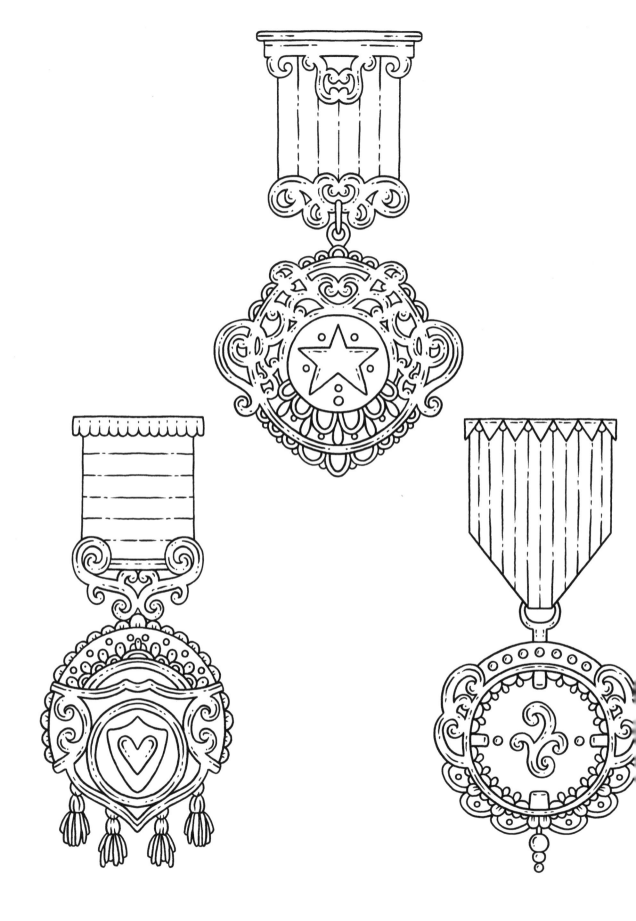

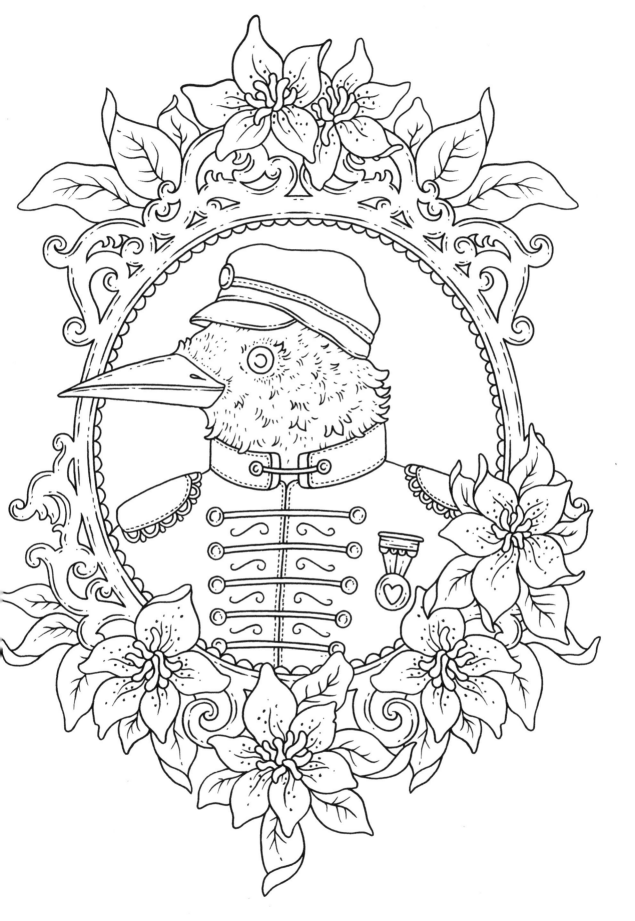

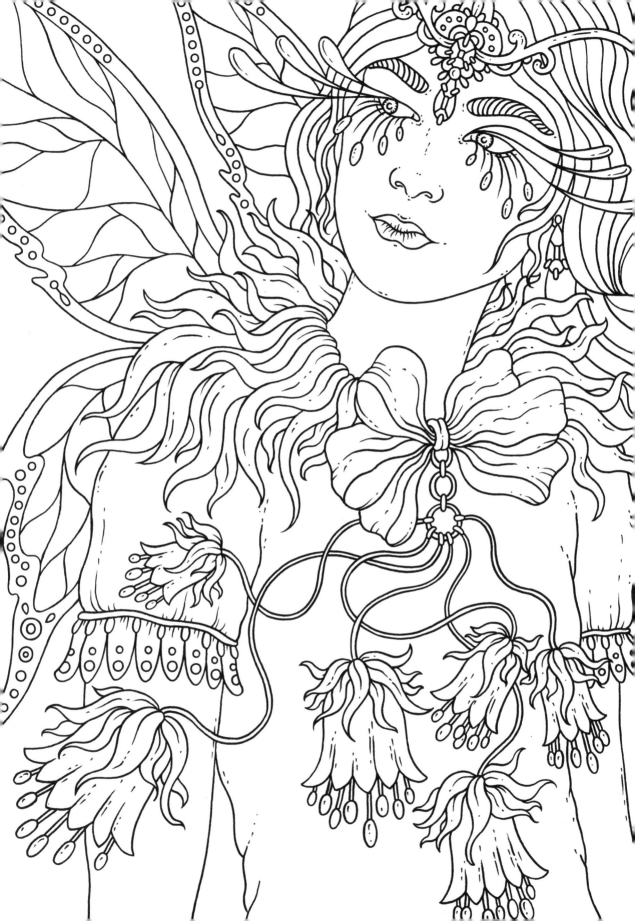

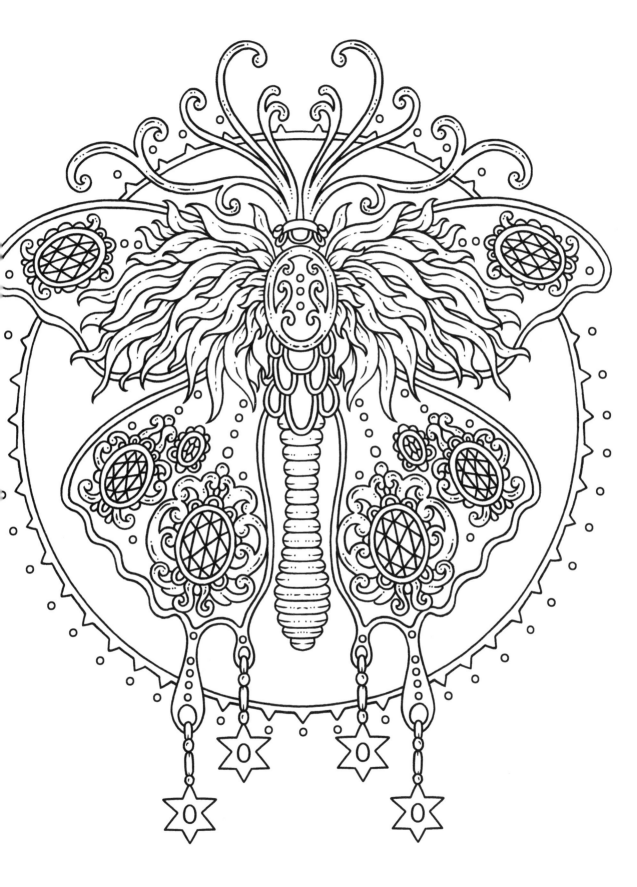

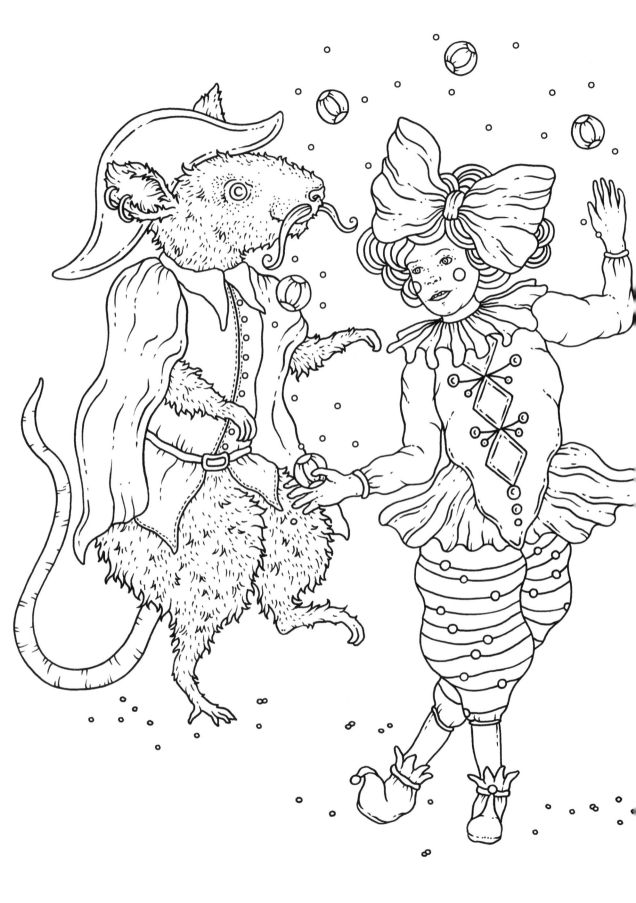

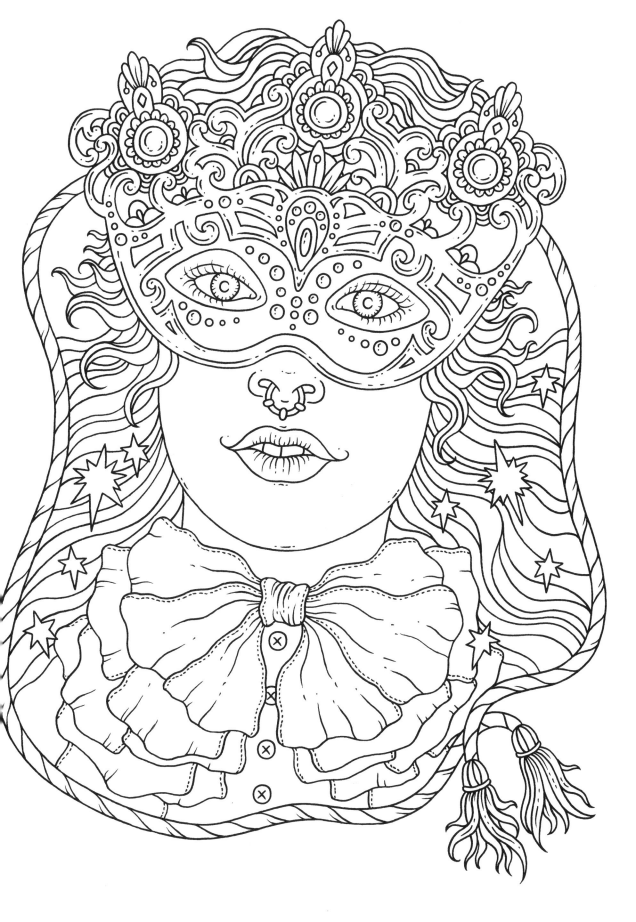

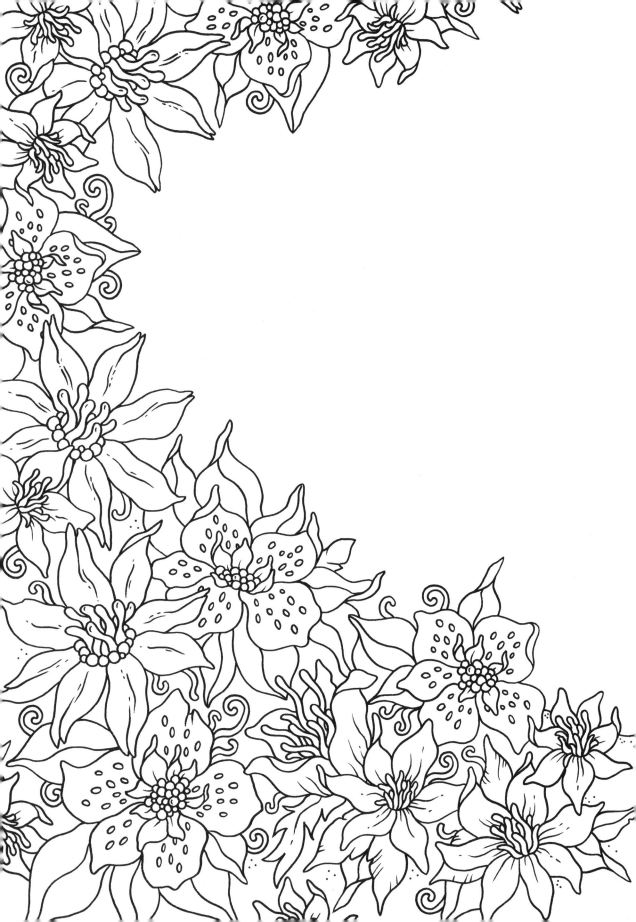

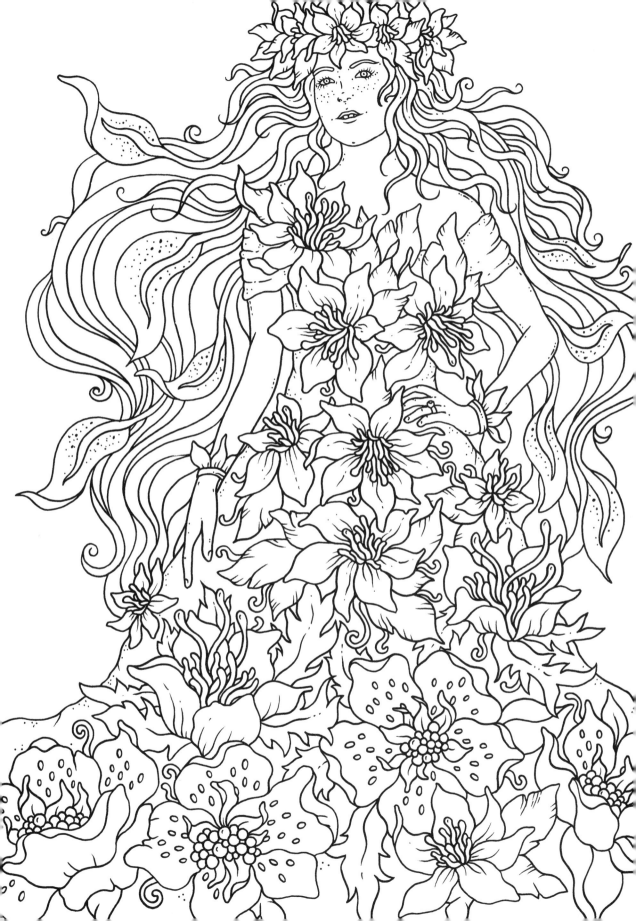

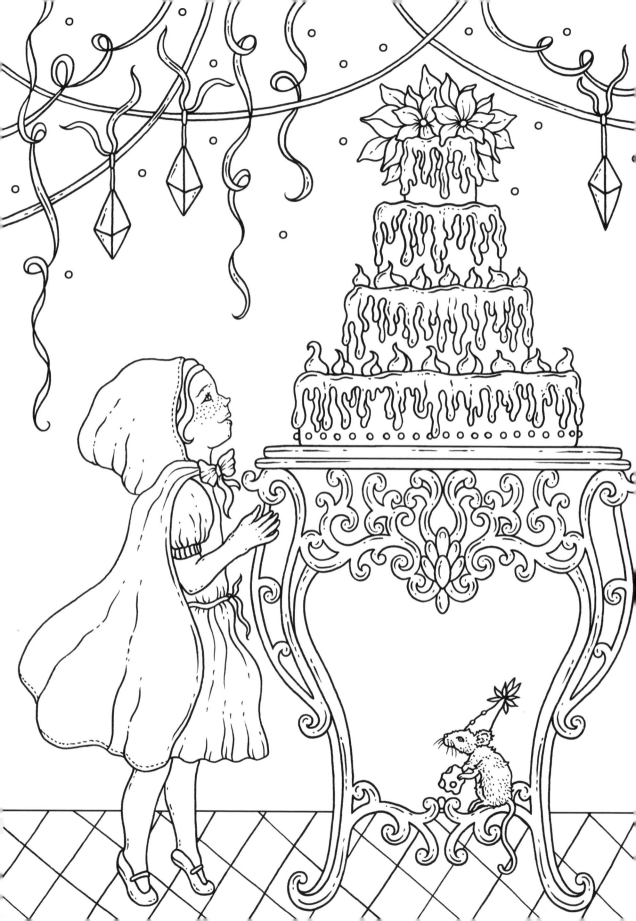

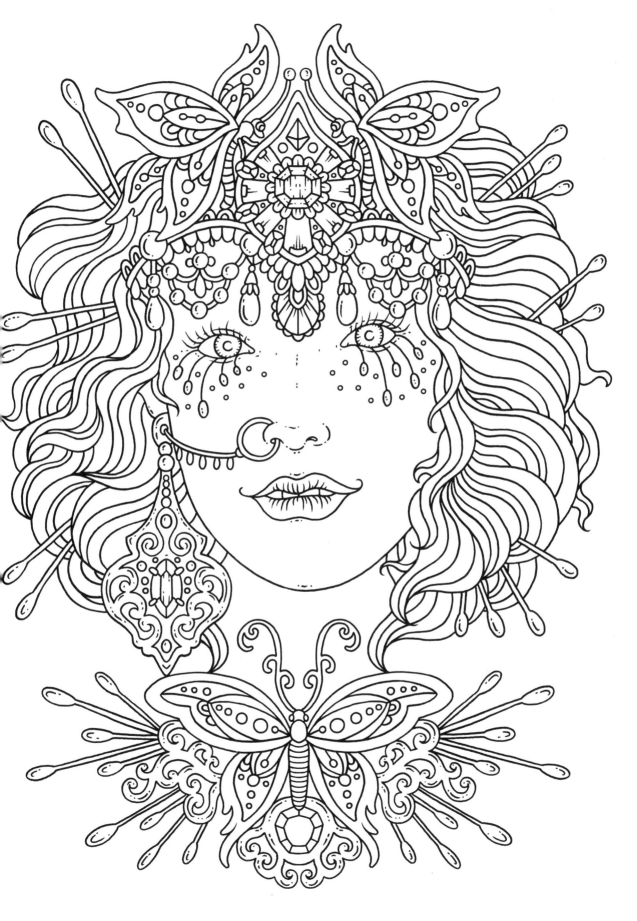

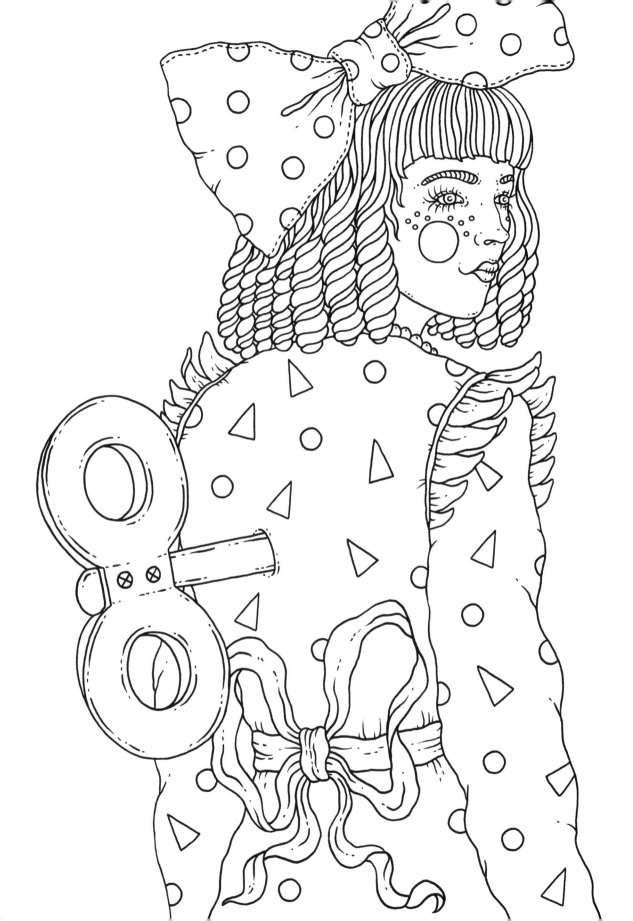

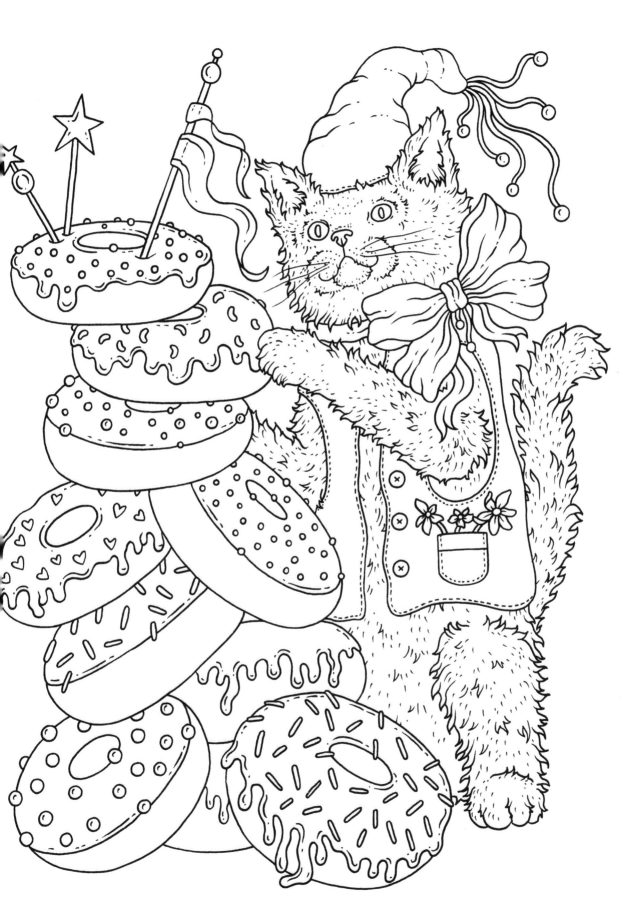

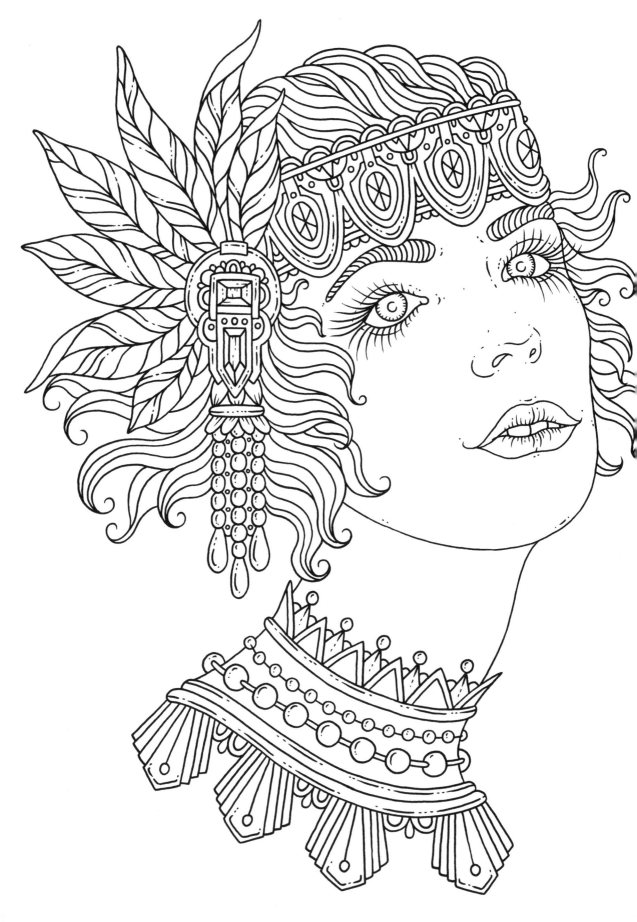

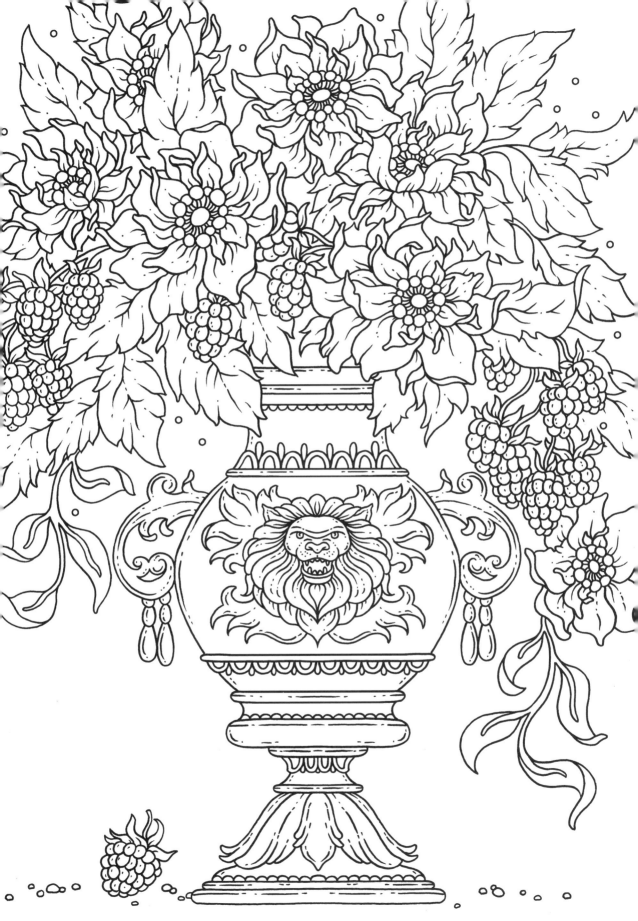

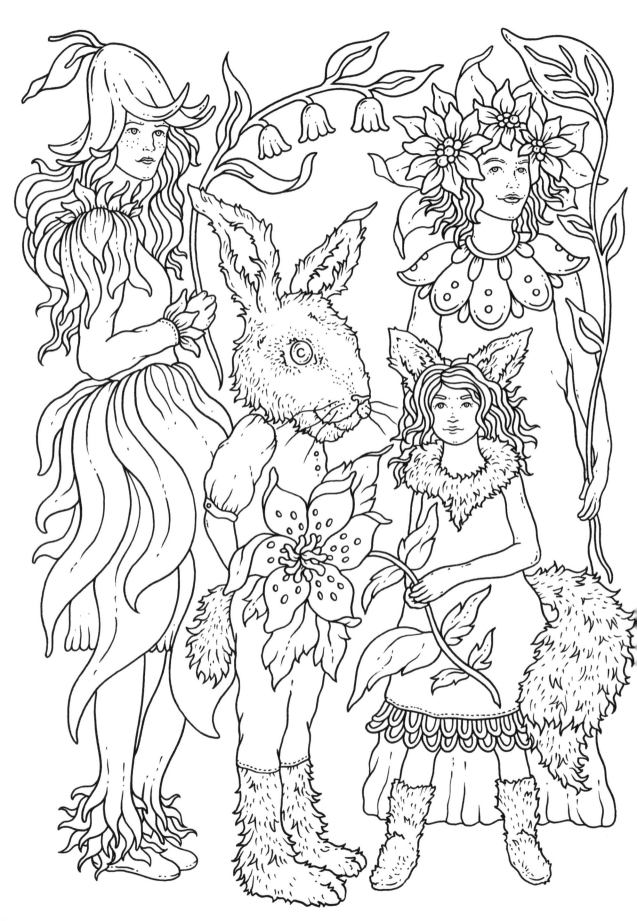

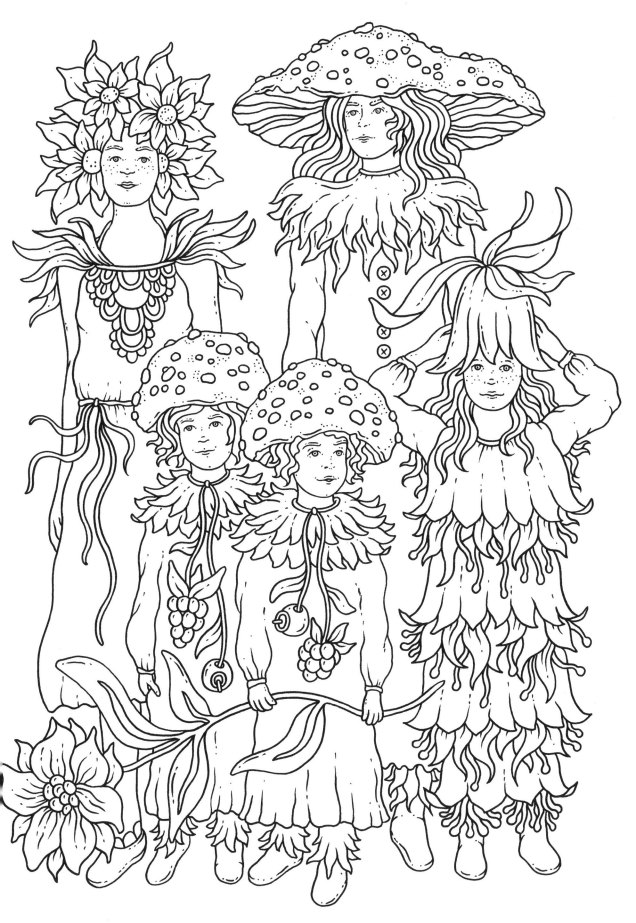

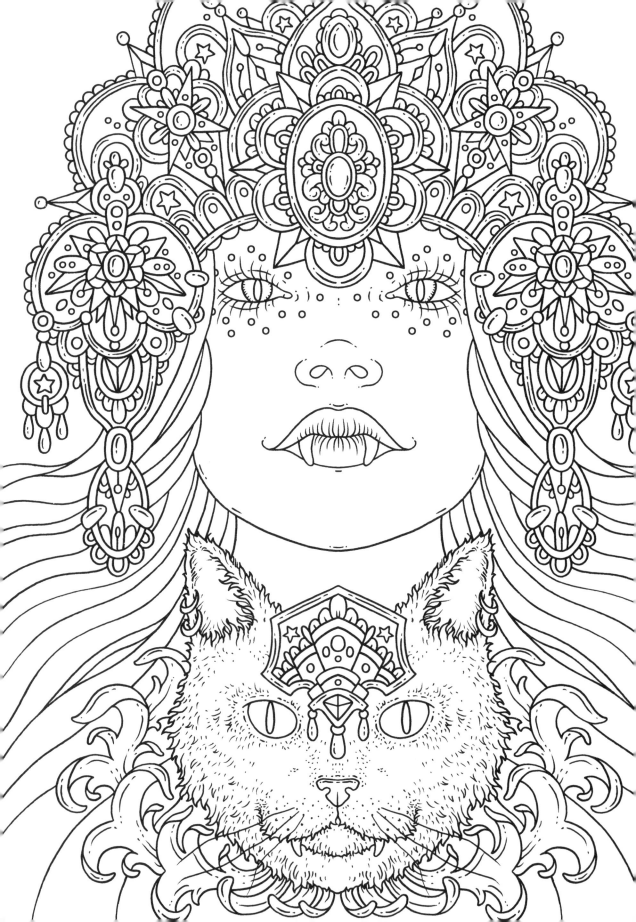

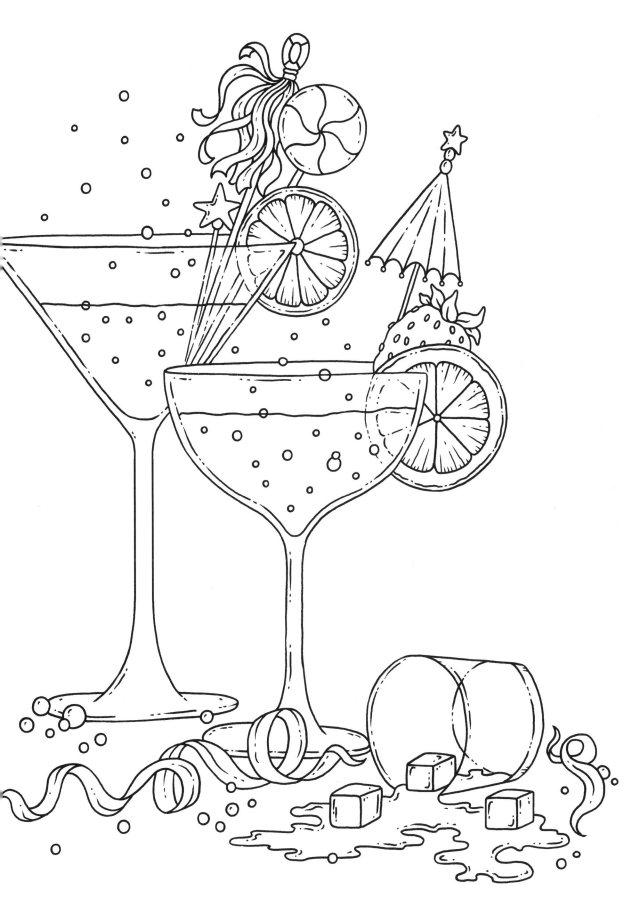

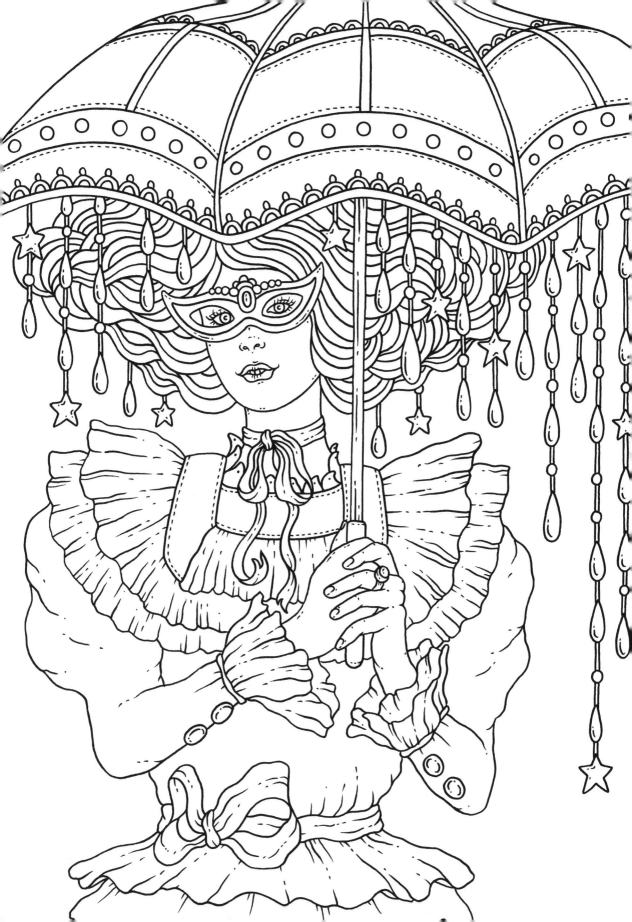

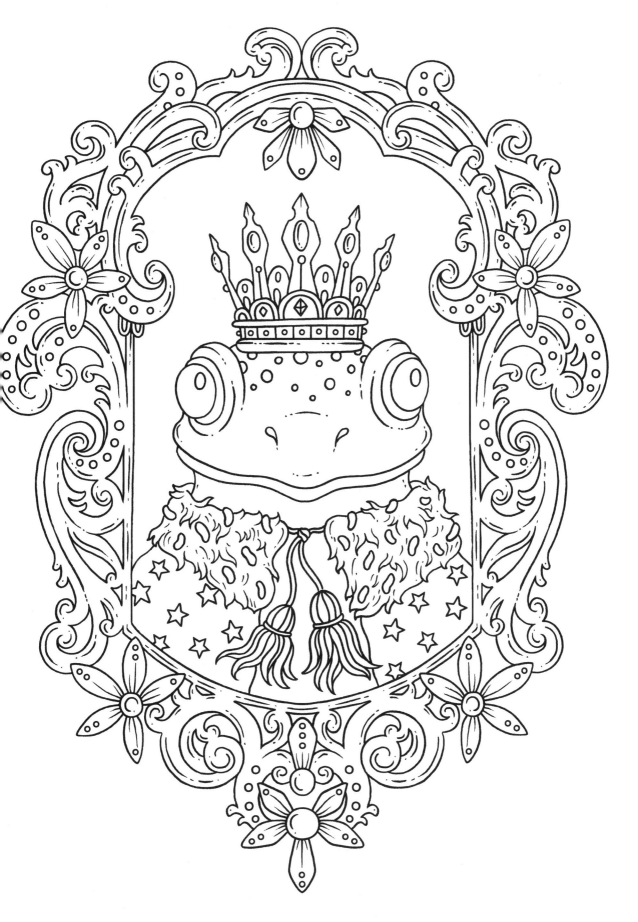

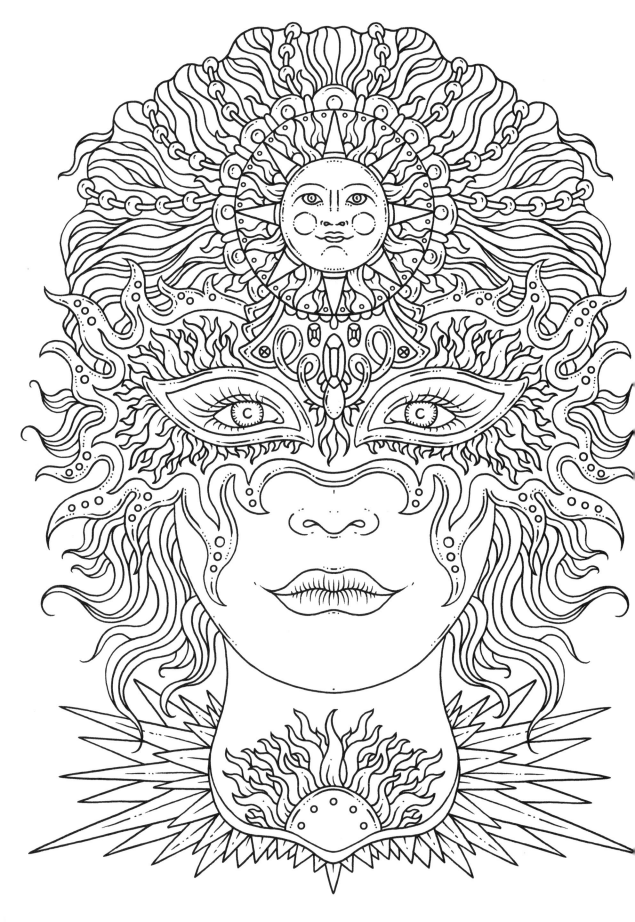

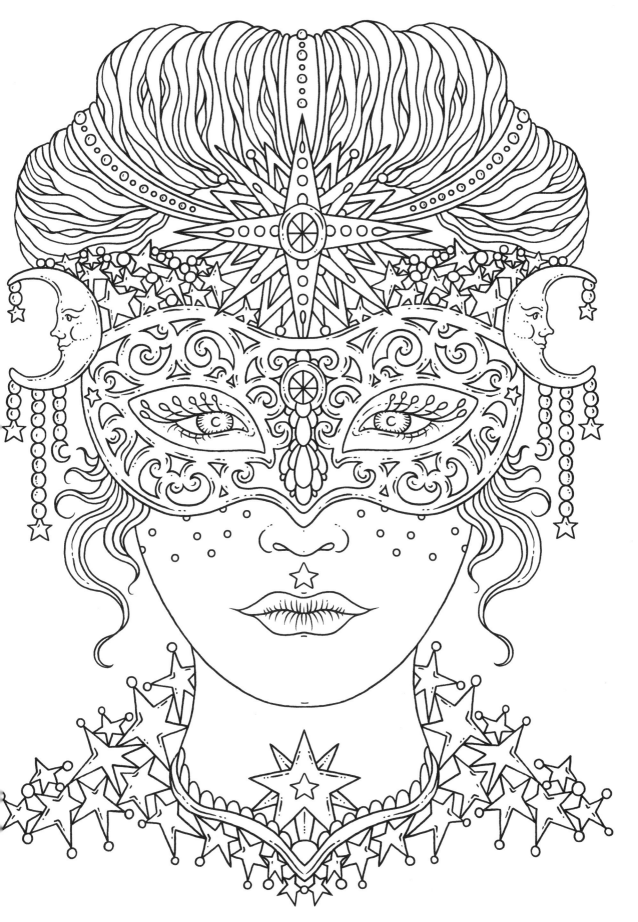

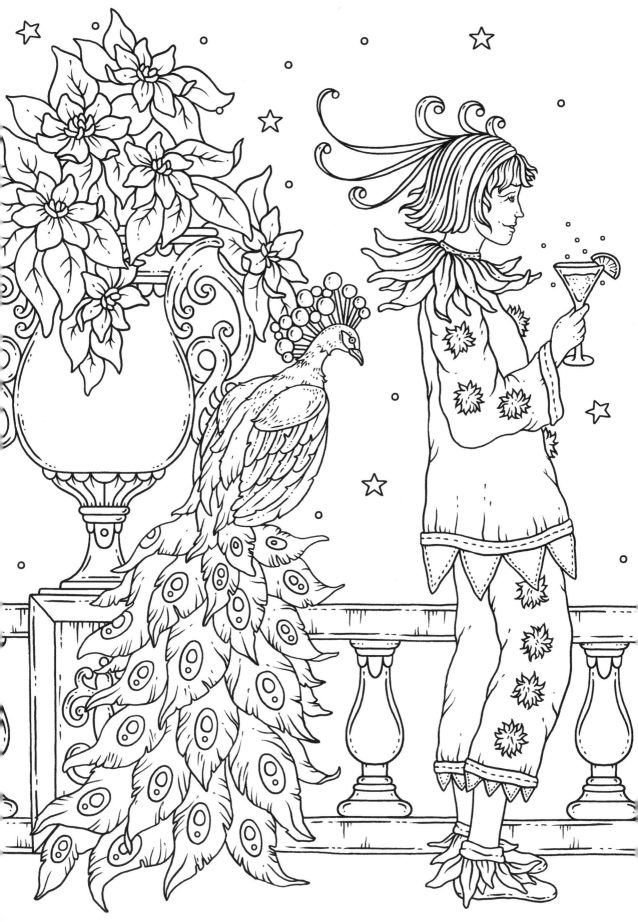

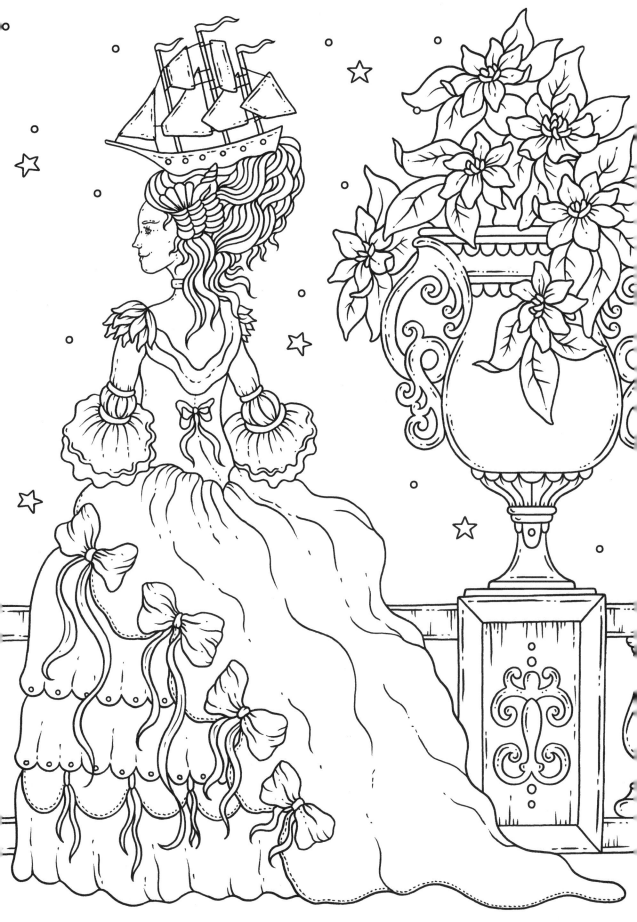

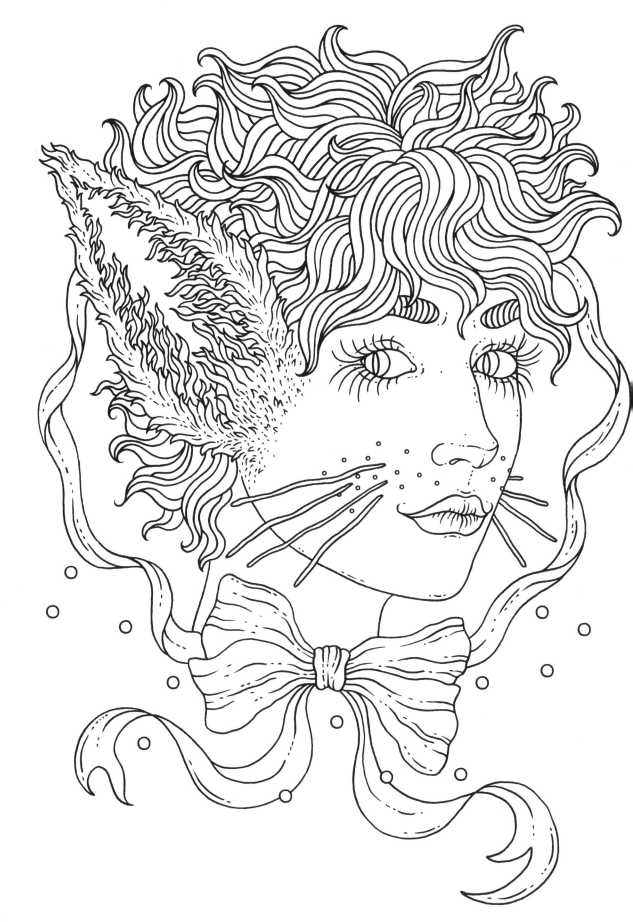

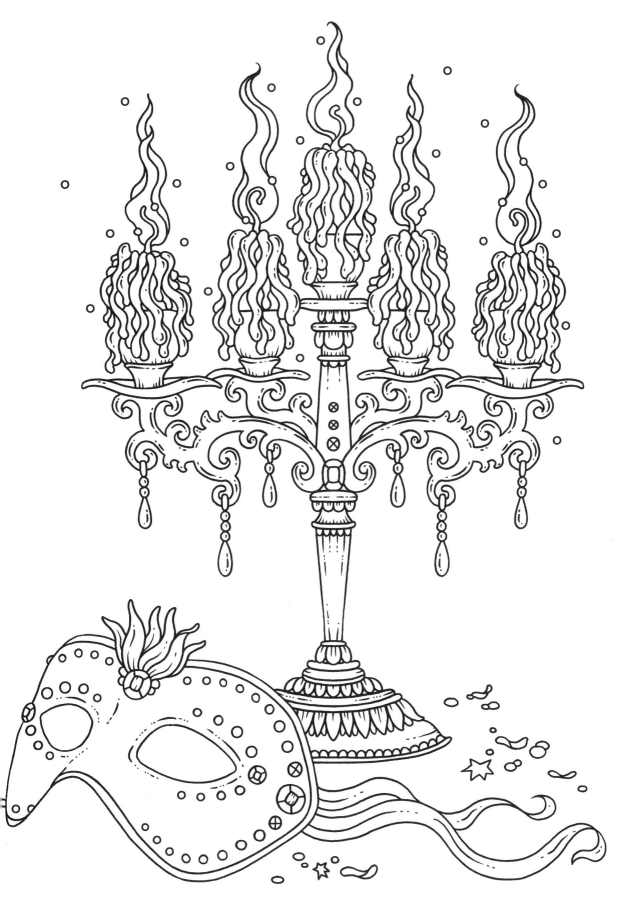

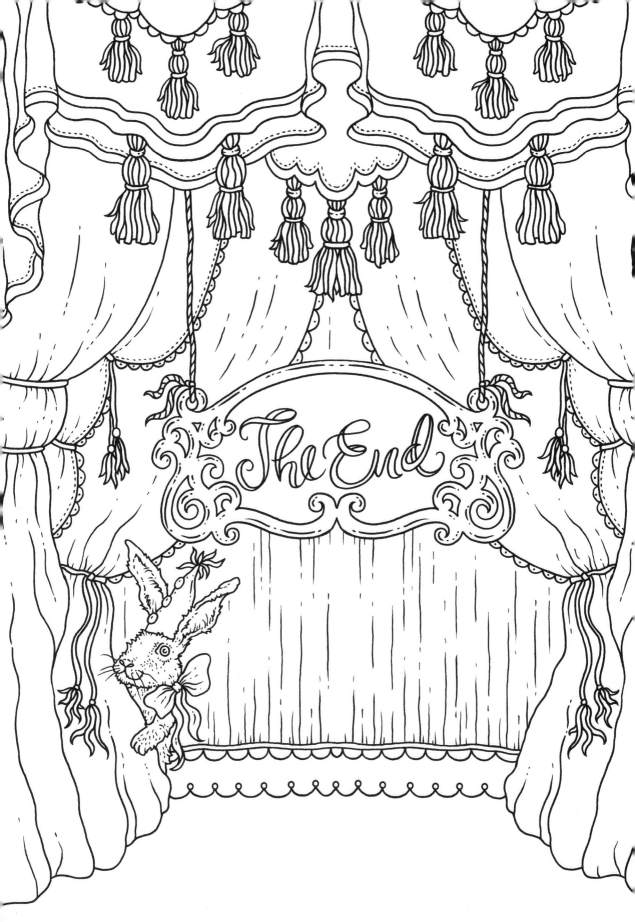